Elegance

Other Works By Len Berry

Vitamin F

Elegance
Len Berry

Lulu.com
2015

Copyright © 2015 by Len Berry

All rights reserved. This book or any portion thereof may not be reproduced or used in any manner whatsoever without the express written permission of the publisher except for the use of brief quotations in a book review or scholarly journal.

First Printing: 2015

ISBN 978-1-312-88299-7

Published by Lulu.com

http://lentberry.wordpress.com

Dedication

To those who always encouraged me, to those who always enjoyed my work,
Thank You, with all of my heart

Contents

Introduction ... 7
Anna Torv .. 8
Grace ... 10
Carmilla ... 12
Emma Stone .. 14
Utada .. 16
Lily .. 18
Elizabeth ... 20
Le Chevalier D'Eon .. 22
The Woman In The Dress .. 24
"Sleep" .. 26
Hair Study ... 28
Brill'Que .. 30
Kathryn Angel .. 32
Kathryn, a closer view ... 34
Alindra Vordrinn .. 36
"Transition" ... 38
Cybergoth 1 .. 40
Cybergoth 2 .. 42
Cybergoth 3 .. 44
Phoenix ... 46
Papers and Implements .. 48

Introduction

My high school basketball coach once said, "Every woman is beautiful."

With that in mind, I present the following images, drawings I have put together over the course of several years. The singular theme here is the inherent beauty found in vastly different women. Real or fictional, everyday or scene in appearance, I feel these ladies all offer something pleasing to the eye, as well as the soul.

In the journeys I've taken with my pencils and pens, I've always looked for that inherent beauty, that note of elegance that makes one look for a moment longer than they would have otherwise.

It's my hope that as you look through this book, you find reasons to stop on a few of the pages and wonder. Taking a moment to see something beautiful is never a terrible thing.

<div style="text-align: right;">
--Len Berry

January 31, 2015
</div>

Anna Torv

Fringe is one of my favorite television shows. I still think about the crazy cases, the maddening twists, and the amazing characters.

While many fans choose John Noble as their favorite cast member, I like Anna Torv the best. She played Olivia Dunham, an FBI agent who might have been the most subdued character in TV history.

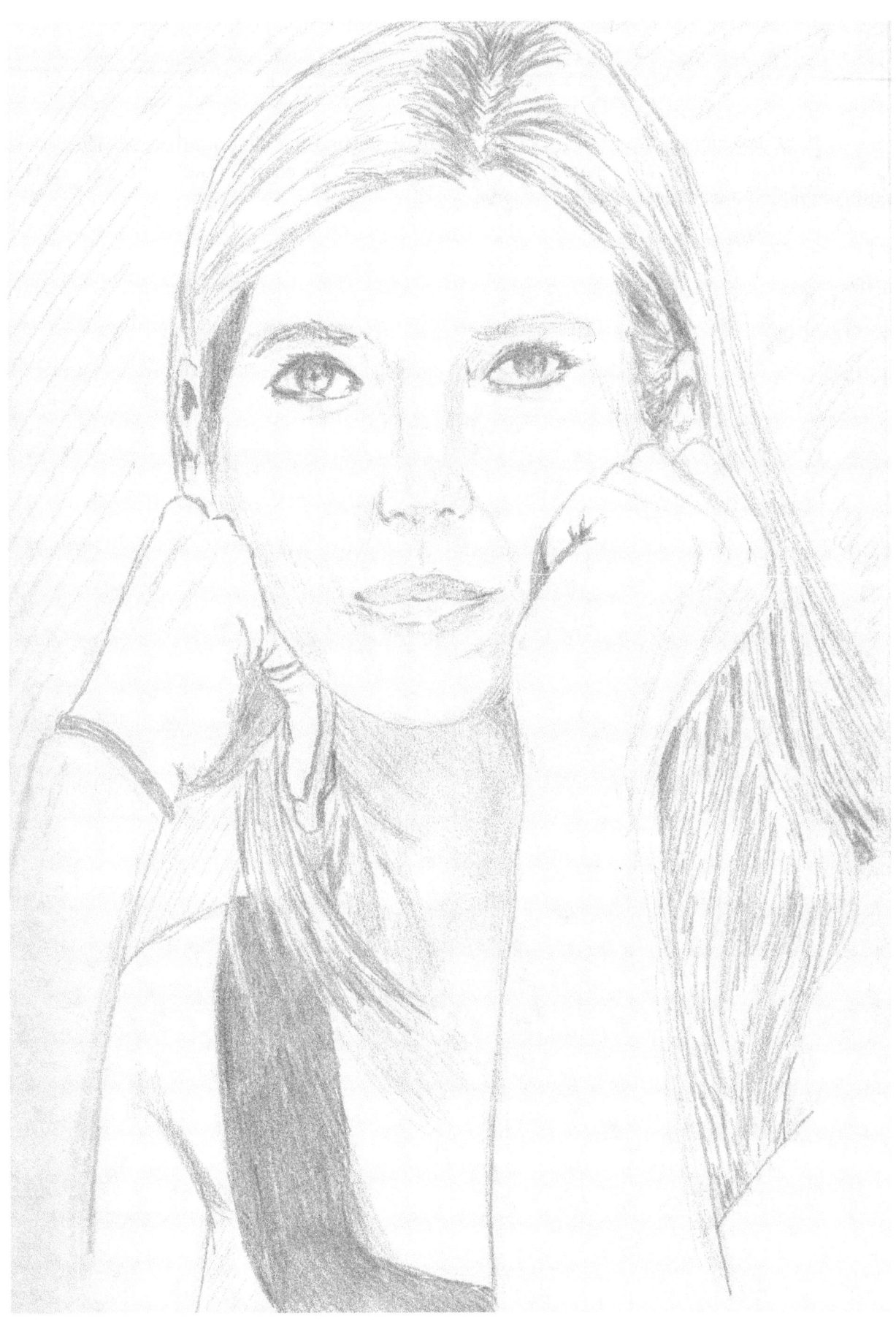

Grace

In 1949, appearances were based more on hair styles and the clothing design. The movie *Gangster Squad* took full advantage of this by placing Emma Stone on a number of posters. Her red hair and red dress create quite the image.

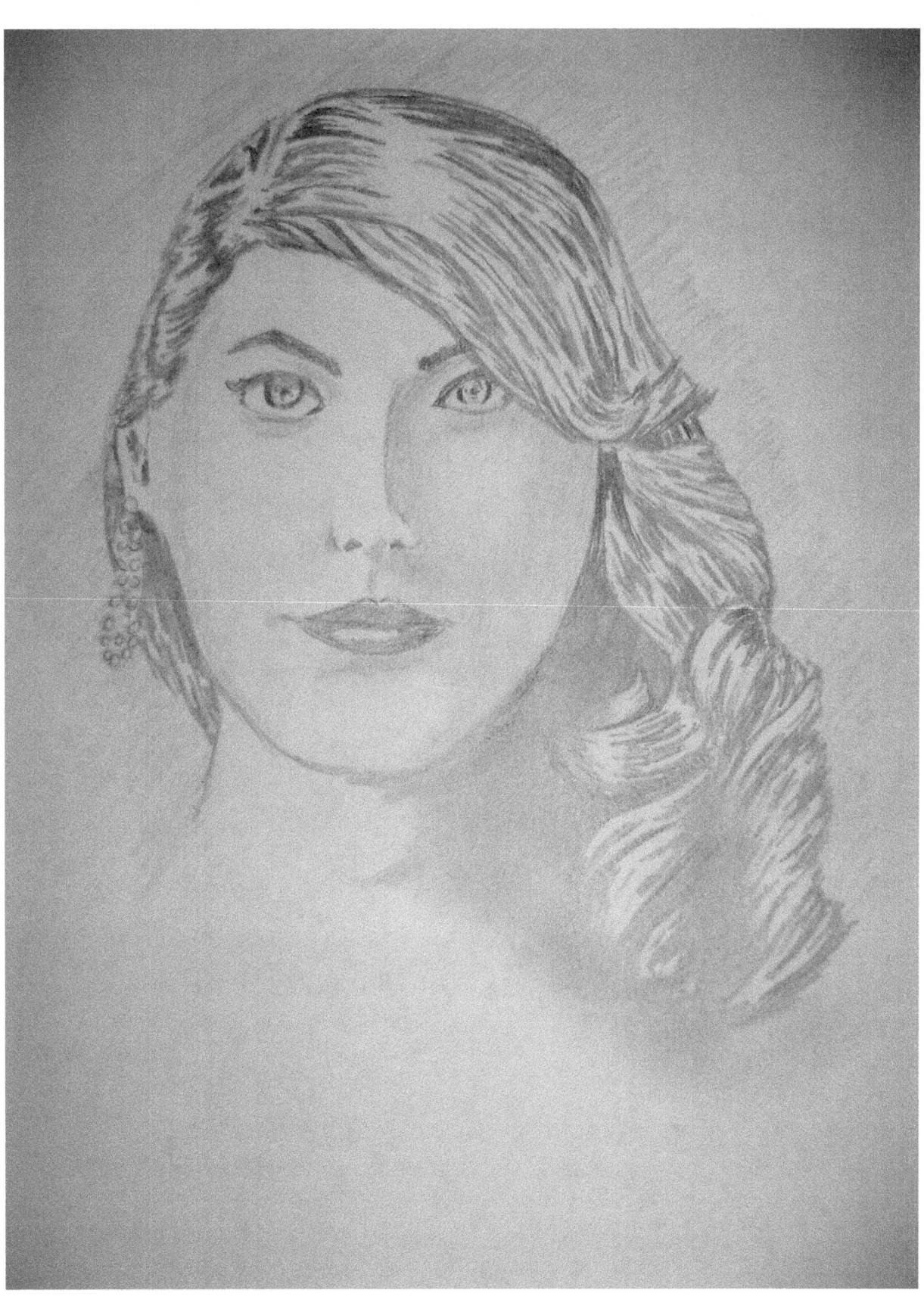

Carmilla

Cosplayer Yaya Han first came to my attention with her elaborate and accurate portrayal of the manipulative Carmilla from *Vampire Hunter D: Bloodlust*.

If nothing else, she makes for one distinctive vampire.

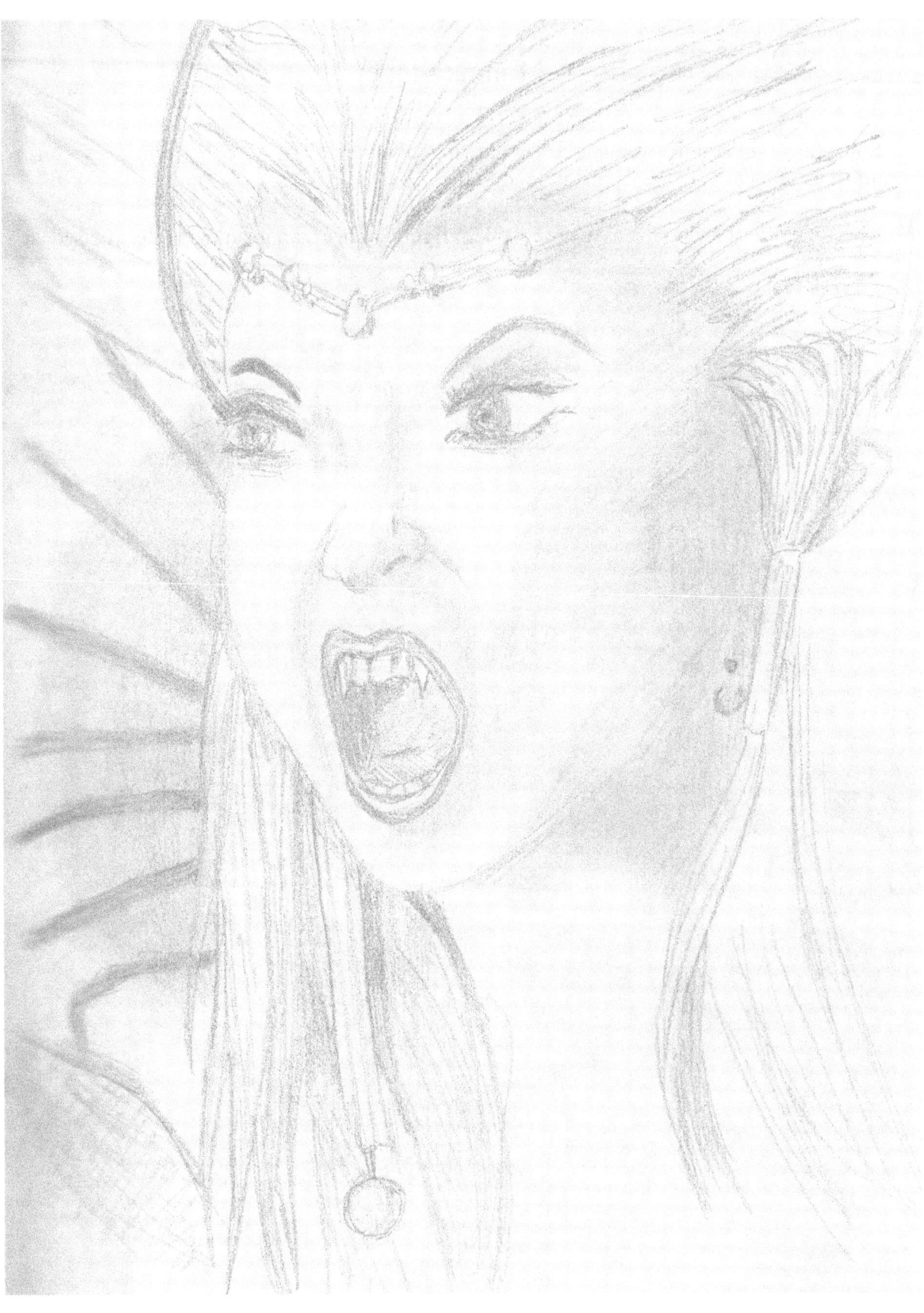

Emma Stone

Something about this woman keeps drawing my curiosity. Her performances can be emotional as often as they are laugh out loud funny.

This time, I'm showing her as a more modern figure, rather than in an old Hollywood look.

Utada

Most people in North America have never heard of my favorite singer. In Japan, Utada Hikaru is one of the most popular musical figures in history. Her popularity is so high, she releases English-language albums in the US, under the name Utada.

If you've ever played a *Kingdom Hearts* video game or watched one of the new *Evangelion* movies, you may have heard her music.

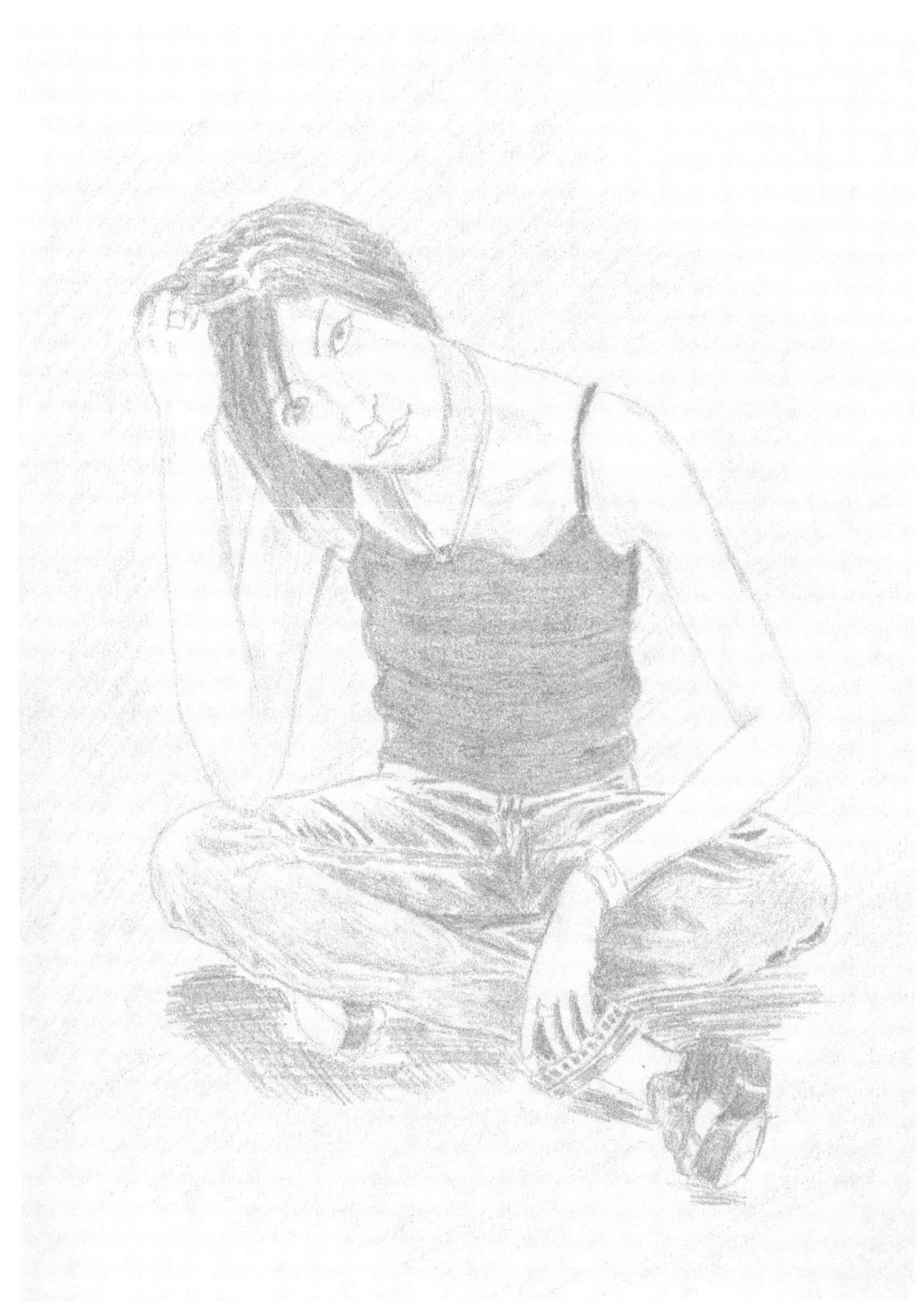

Lily

When I first saw *Legend*, I was struck by the visual of the dance sequence. A weather-weary princess dancing with a shadowy figure in a fire-lit chamber. The magic happens when the two dancers collide and become the same person.

Here is the princess Lily, after her dark transformation.

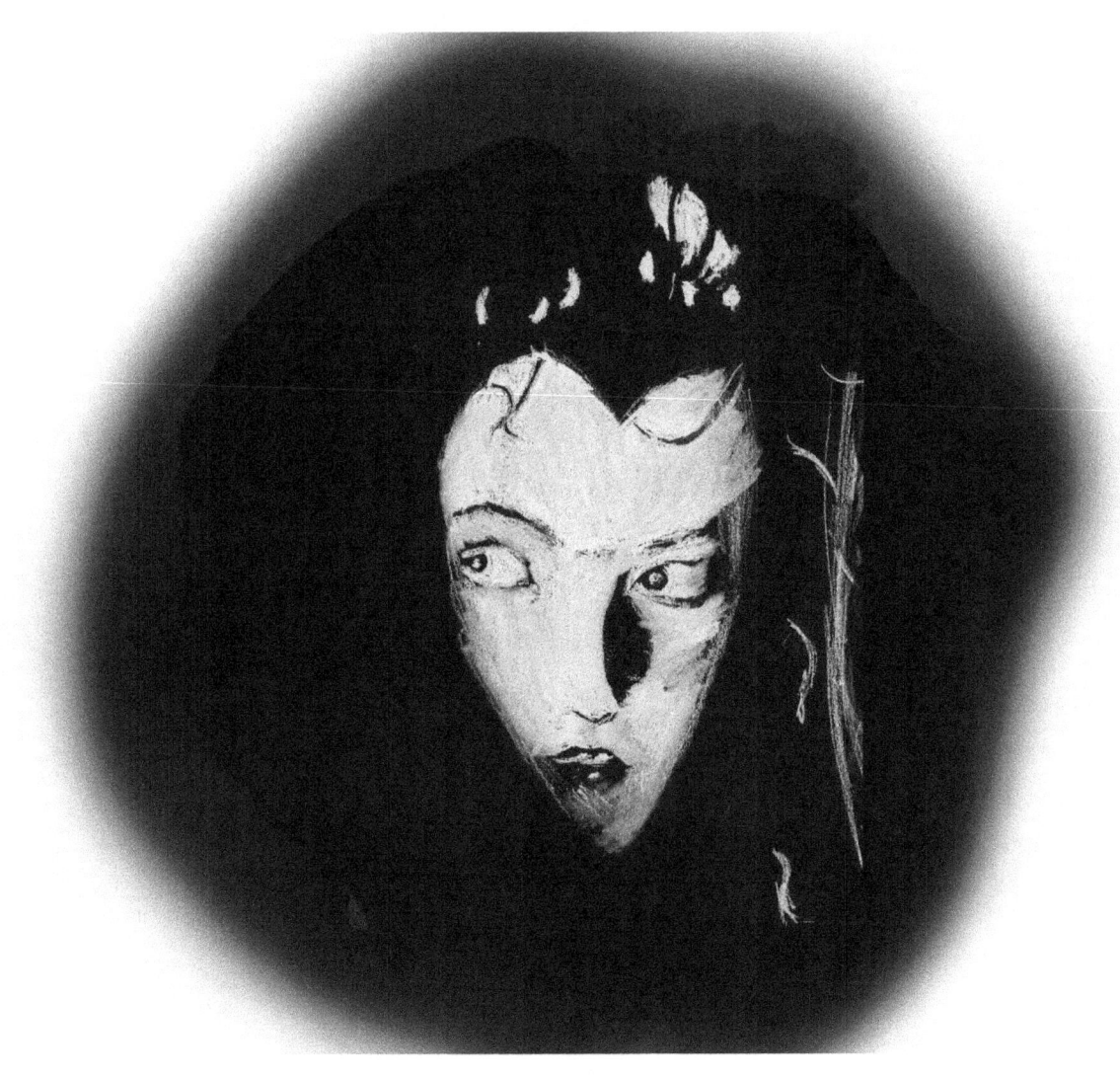

Elizabeth

Her only friend is the Songbird. She dreams of seeing Paris.

Possibly the true star of *Bioshock Infinite*, this young lady is the closest there is to an iconic female lead in the steampunk genre.

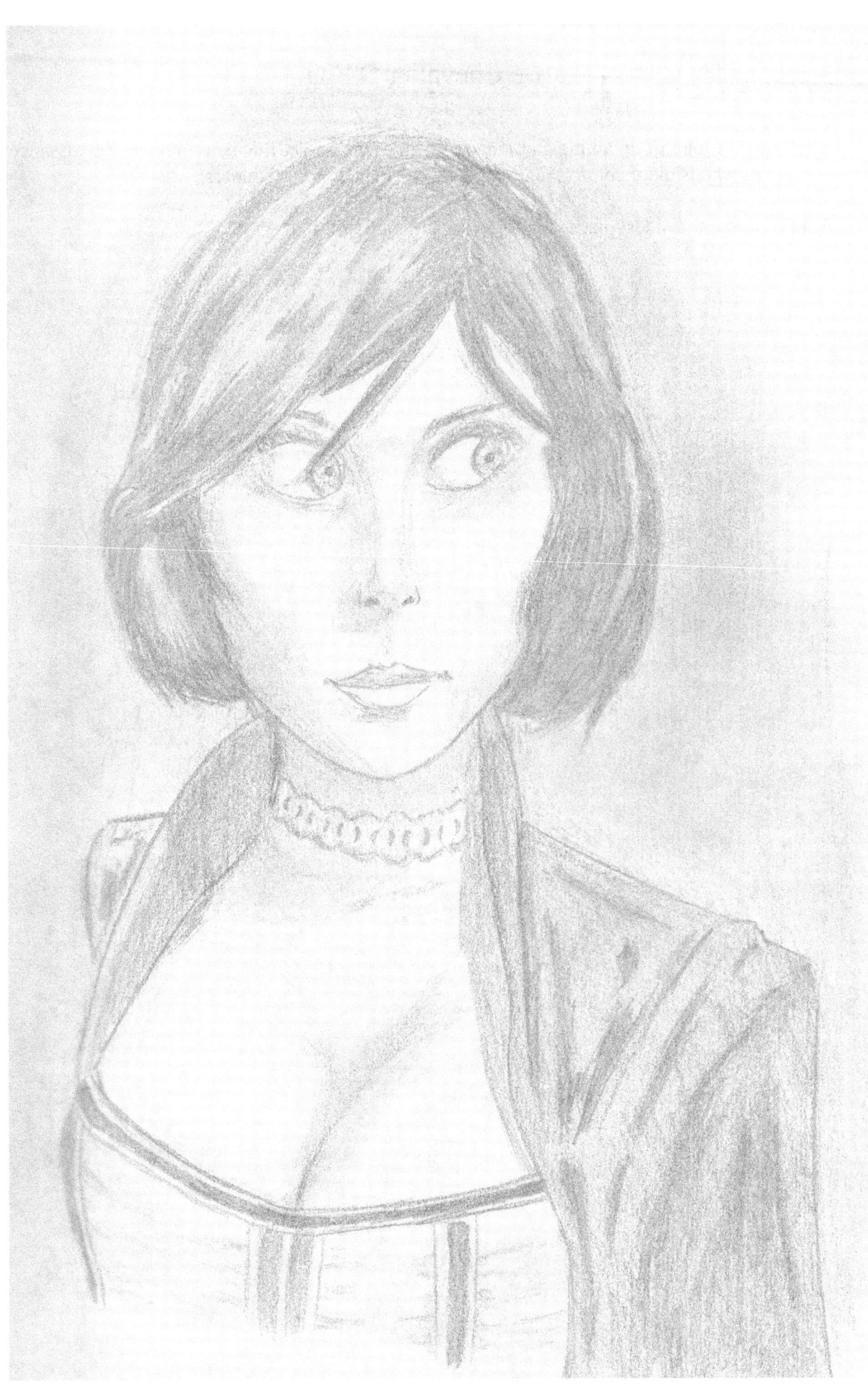

Le Chevalier D'Eon

The central figure of an anime and manga of the same name, this is an intense Renaissance Frenchwoman who is more comfortable with a sword than courtly manners.

This is one of the oldest pieces in this book, though I still like it.

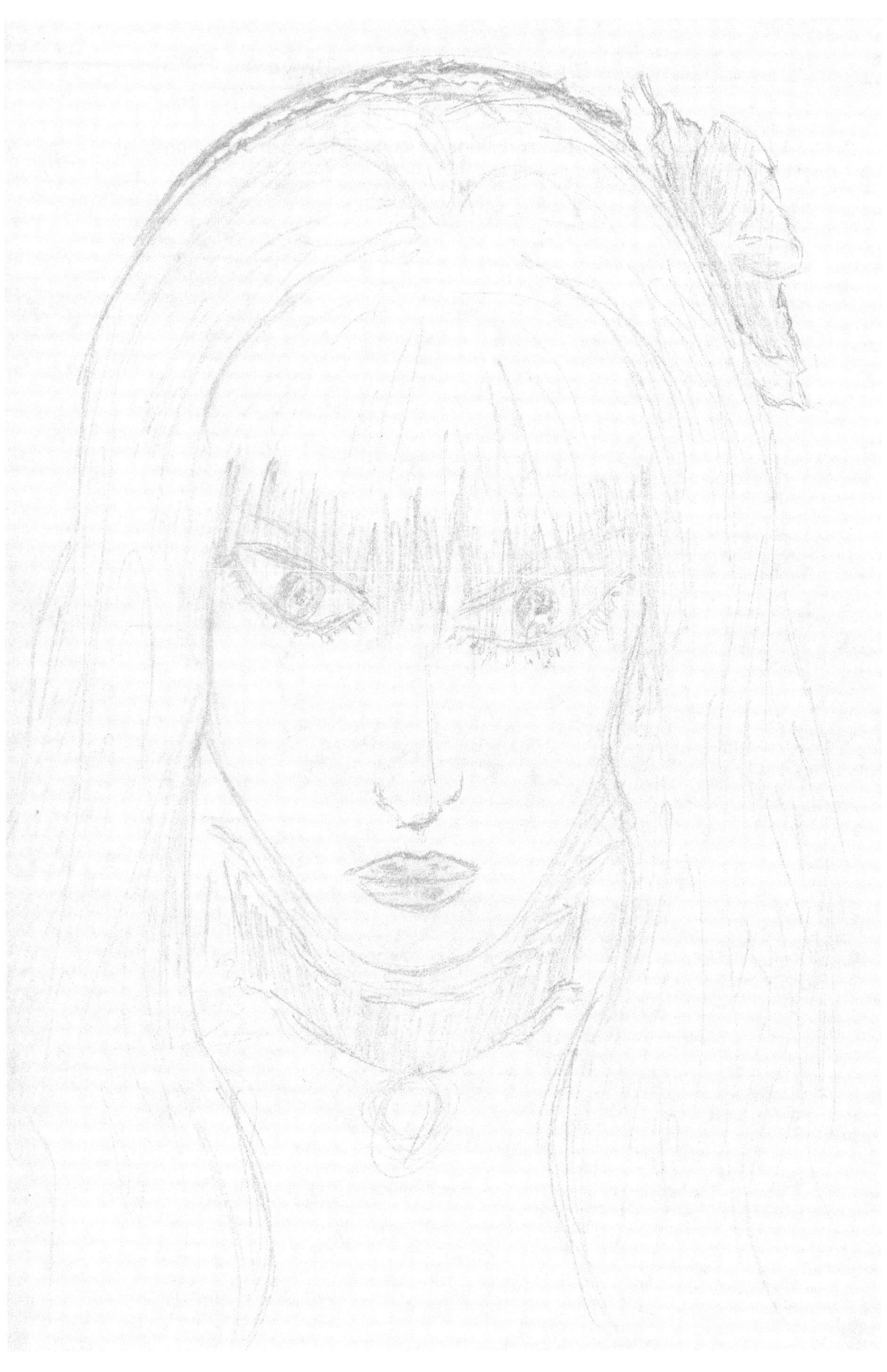

The Woman In The Dress

One of the newest pieces in my collection, I stumbled on a picture online and wanted to draw my version of it. Something simple.

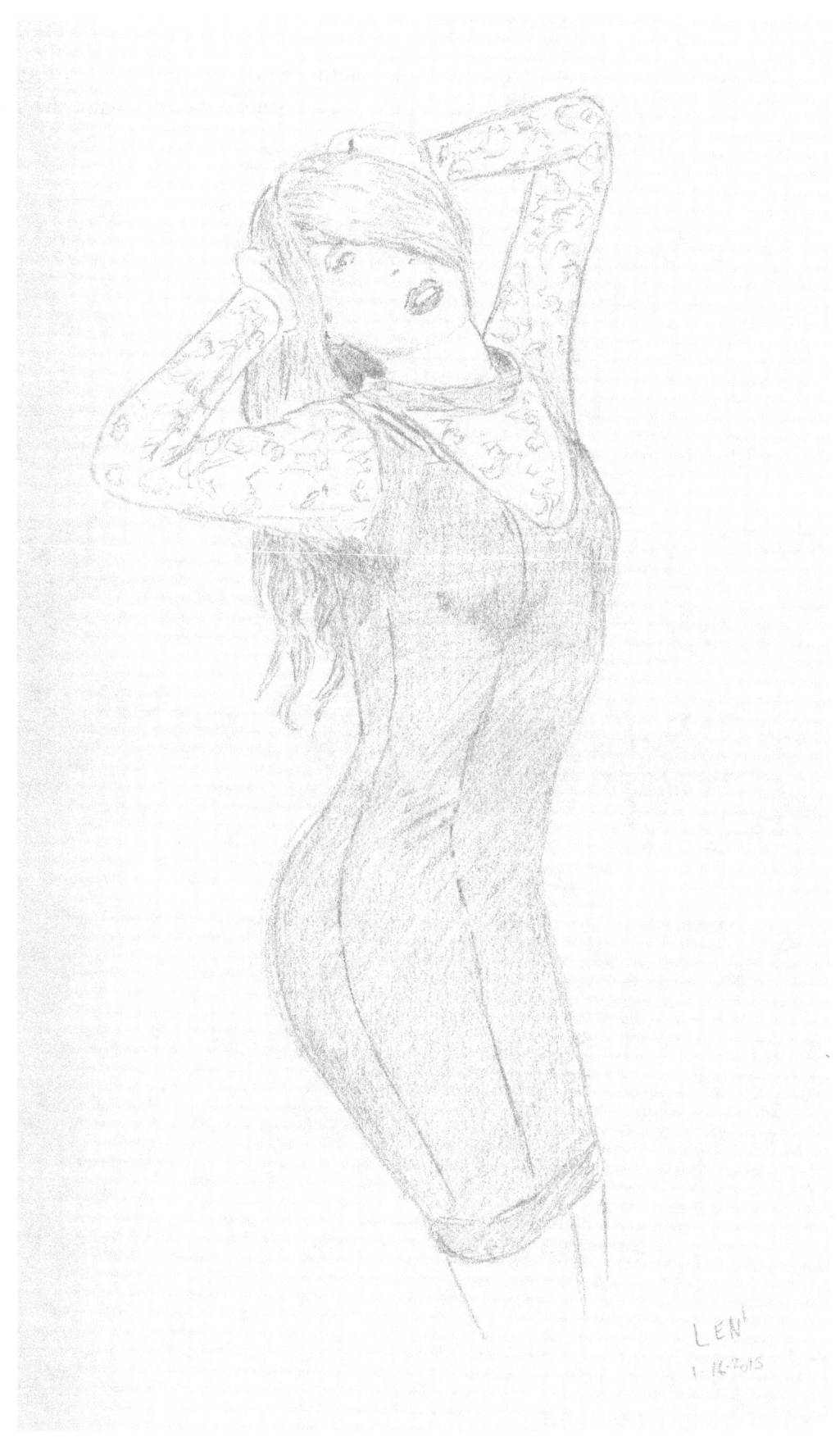

"Sleep"

On trips, I sometimes draw something. I'll start a picture as I leave and finish it just as I get back. During one of these trips, I decided to try my hand at crafting a woman while she sleeps.

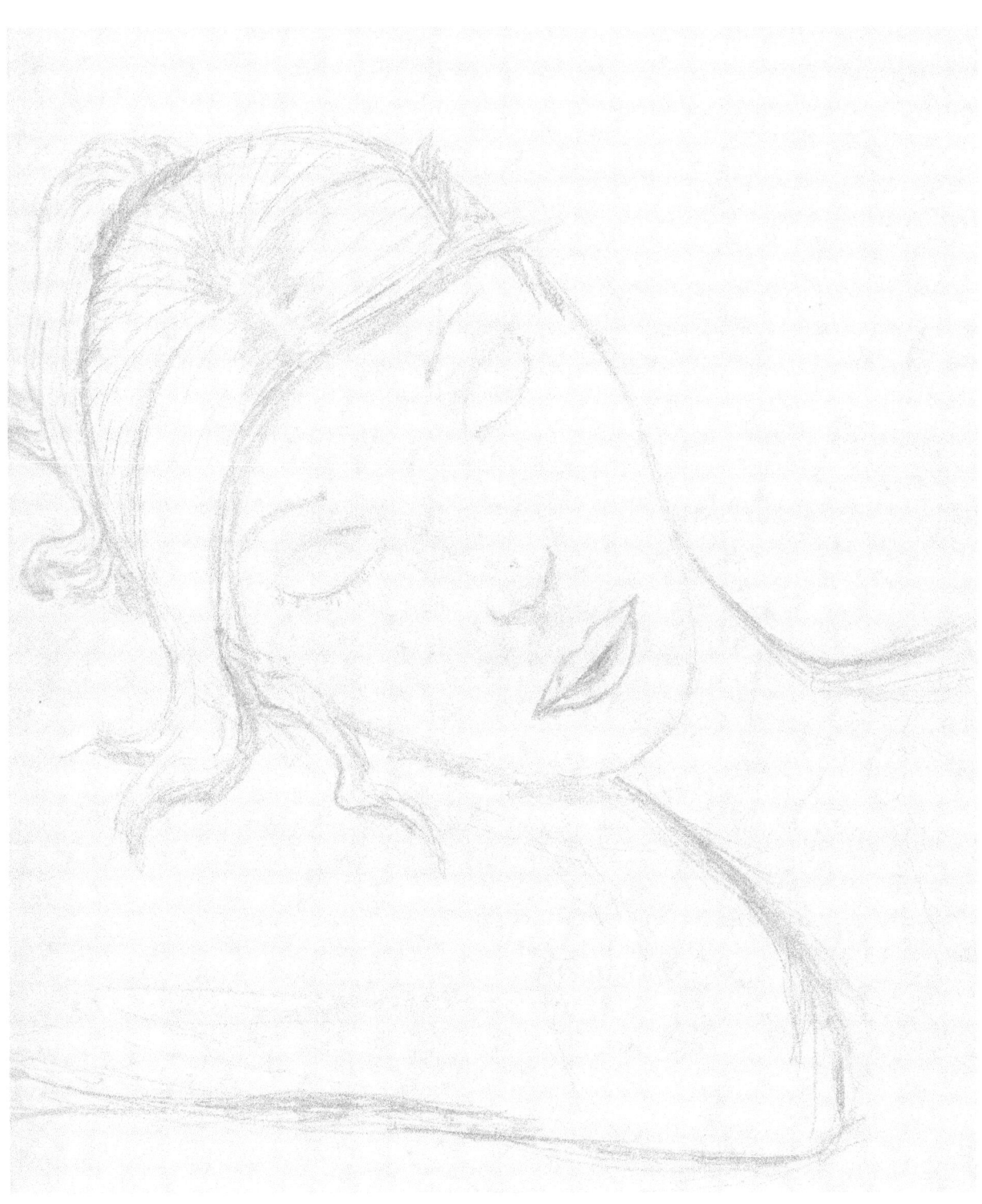

Hair Study

I saw this woman and loved the shape and lighting of her hair. I had to draw her.

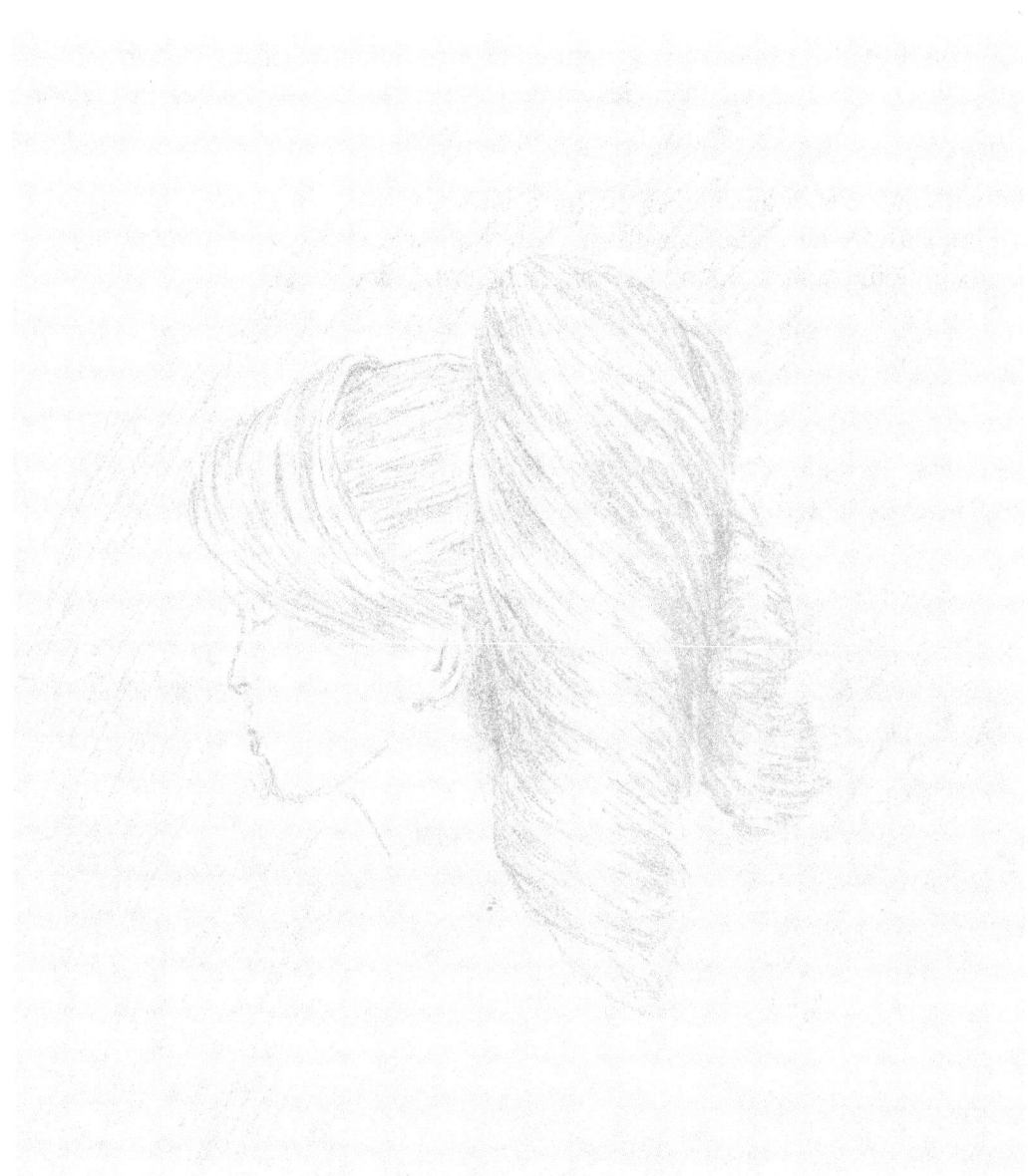

Brill'Que

Part of why I've always drawn is to figure out more about what my characters look like, if only to find the words to craft their descriptions. One such case comes in the form of the Brill'Que.

Fused with the cells of an alien spore, these empowered creatures grow stronger by feeding off normal humans. Aside from their dietary habits, they use every part of their victims, making leather for their clothes and sculpting the bones into armor and jewels.

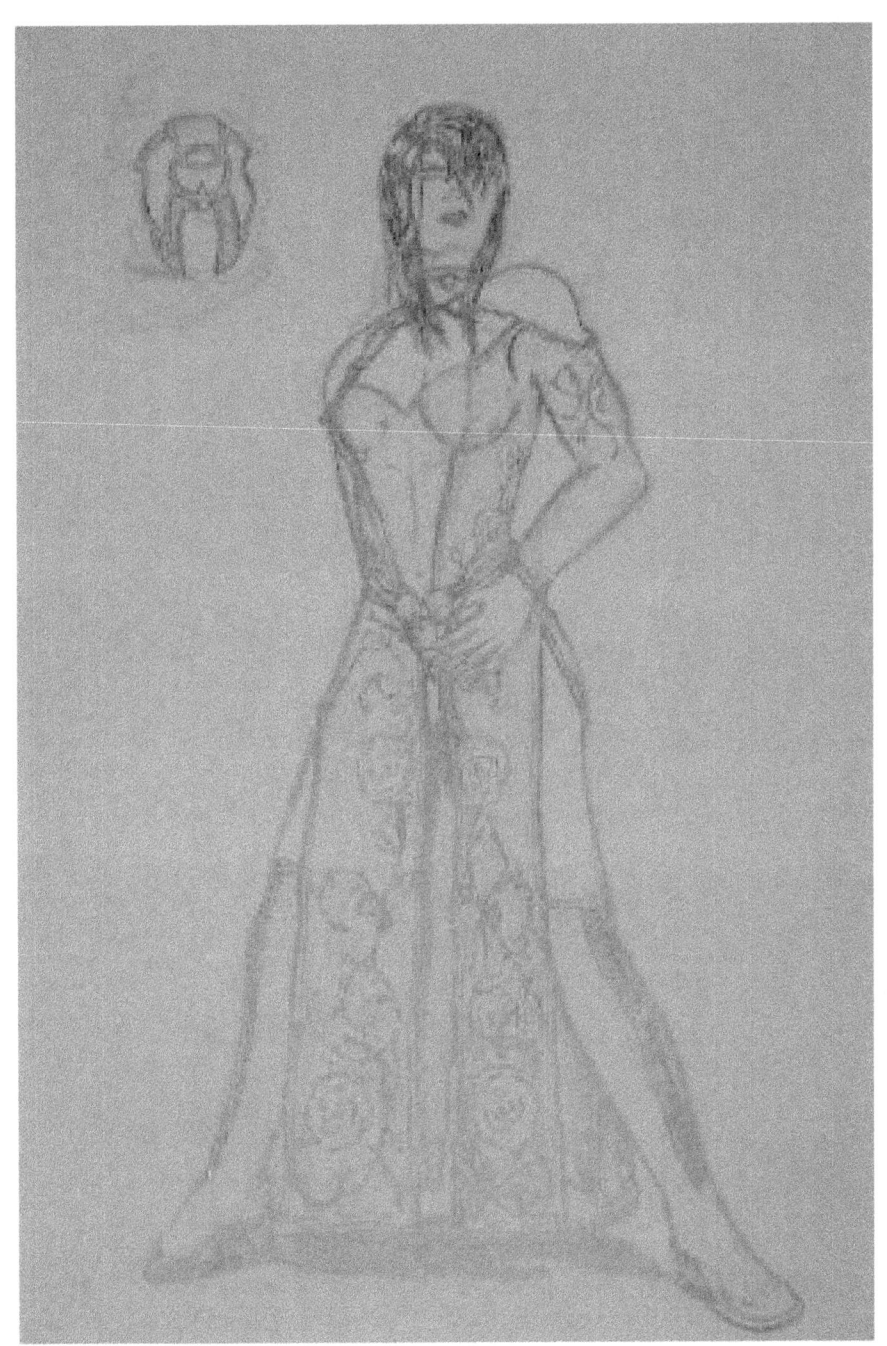

Kathryn Angel

On the opposite side of the spectrum is Kathryn Angel. She's an intelligent woman, happy capable.

No one ever bothered to tell her that she possessed latent telekinetic and telepathic abilities. Even if they had, they certainly wouldn't have dared to tell her that she was the most powerful being on the planet.

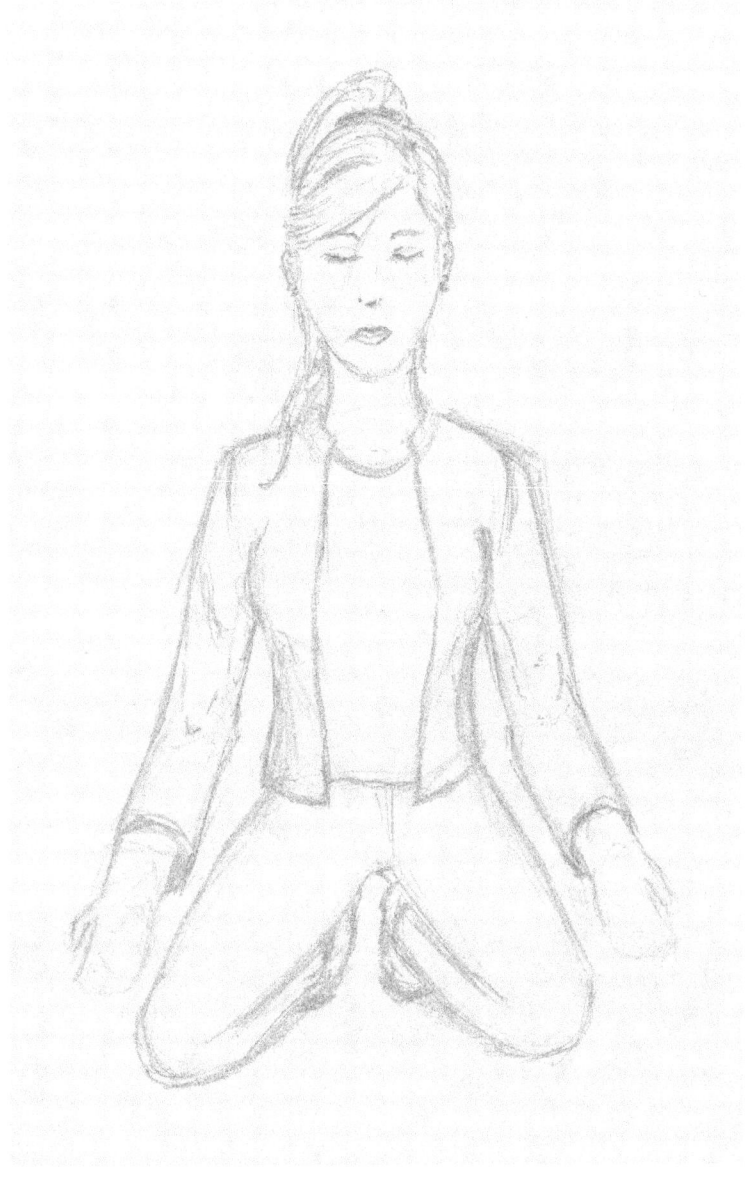

Kathryn, a closer view

Kathryn is my favorite character to write, so it's no surprise that I've drawn her several times.

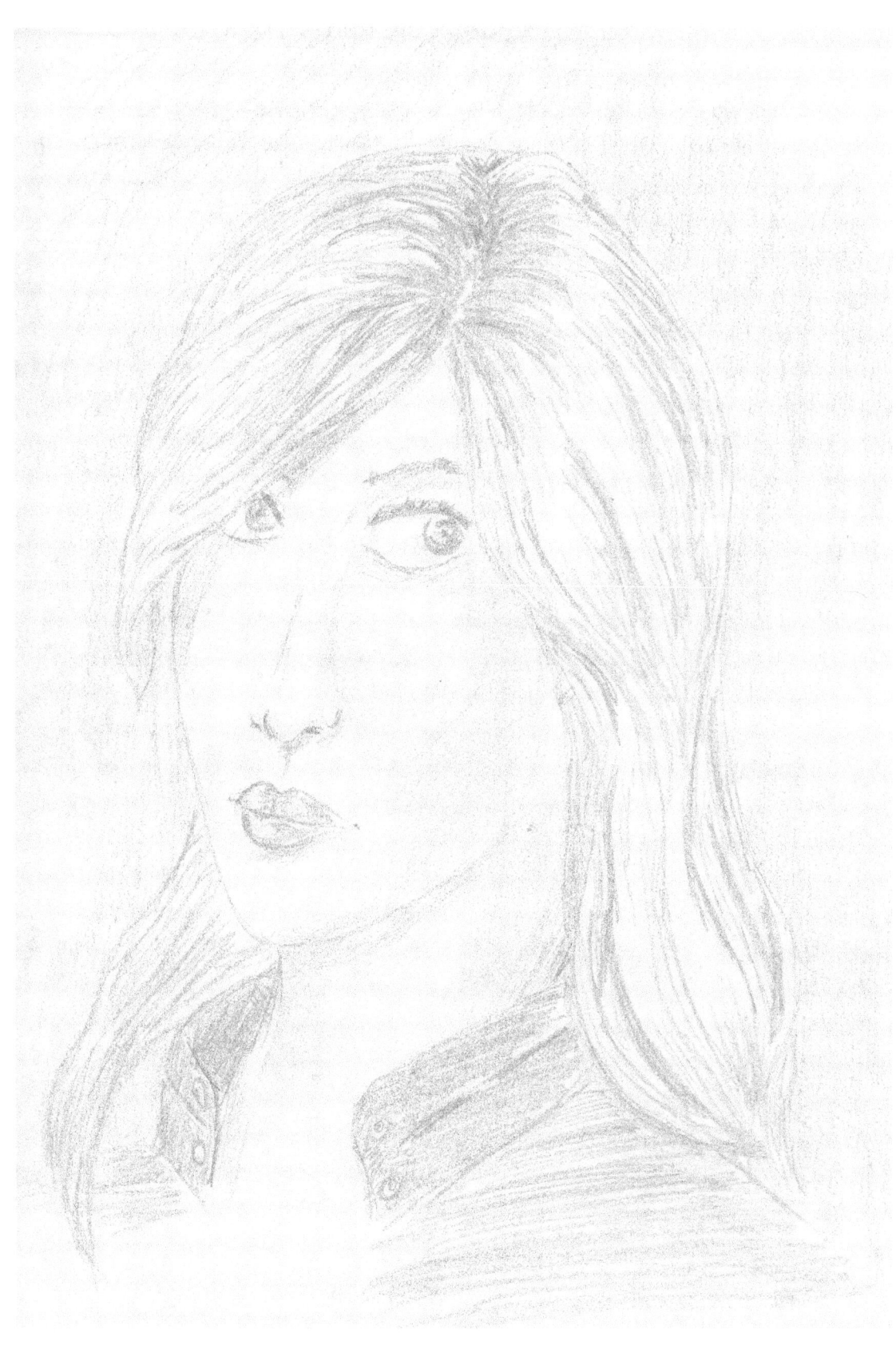

Alindra Vordrinn

In one of my science fiction settings, there is a secret order of empowered peacekeepers known as the Inquisitors. Among them is Alindra Vordrinn, a woman who carries with her a genuine smile that exists in sharp contrast to the violence she can deliver.

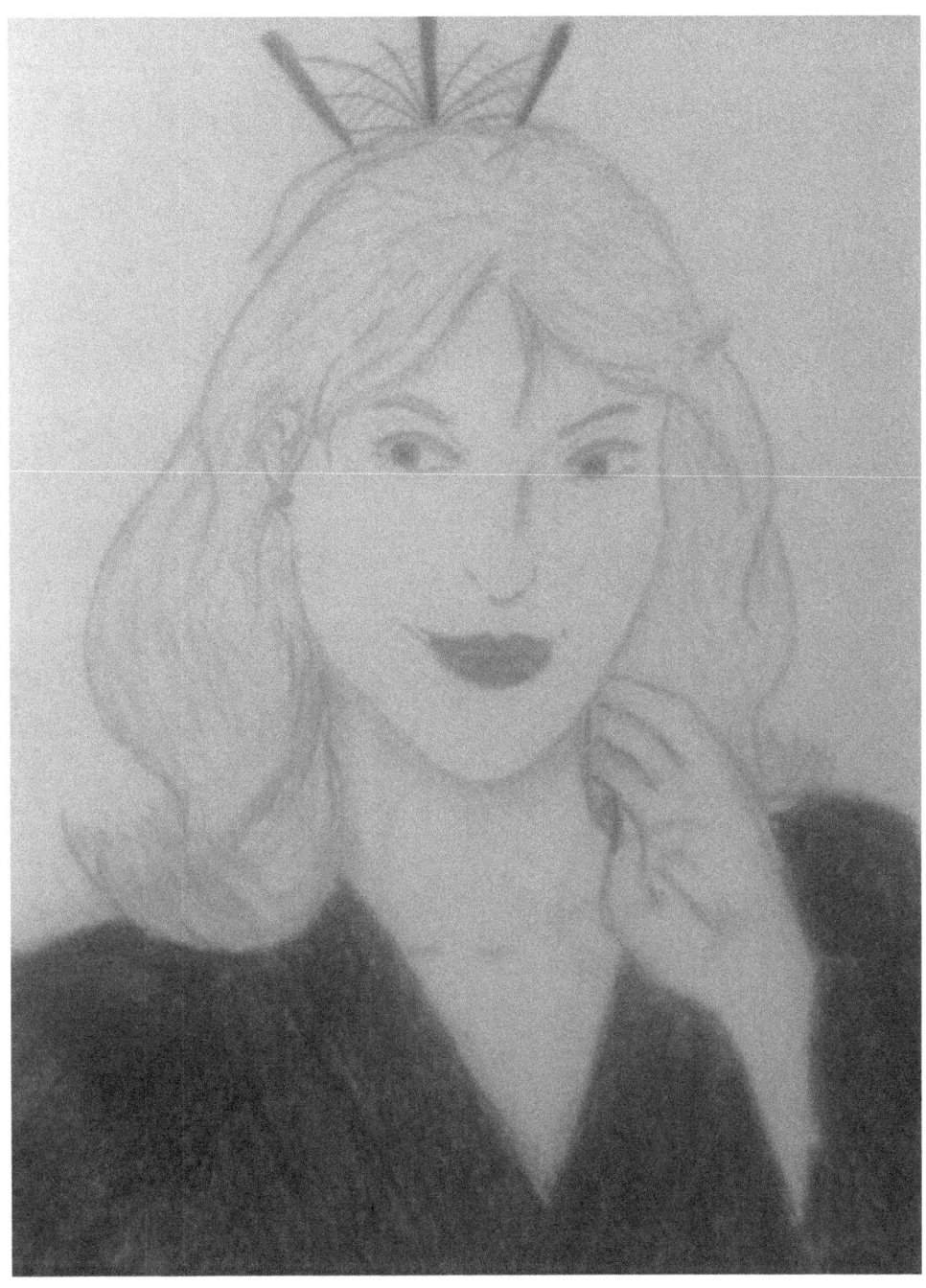

"Transition"

A horror concept, this is a woman struck by a curse designed to change her into a more bestial creature. In this case, she's becoming more like a spider after feeding upon a victim in an intimate setting. Spines are beginning to emerge from her body, her skin is turning into a pallid carapace with breathing slits on her legs.

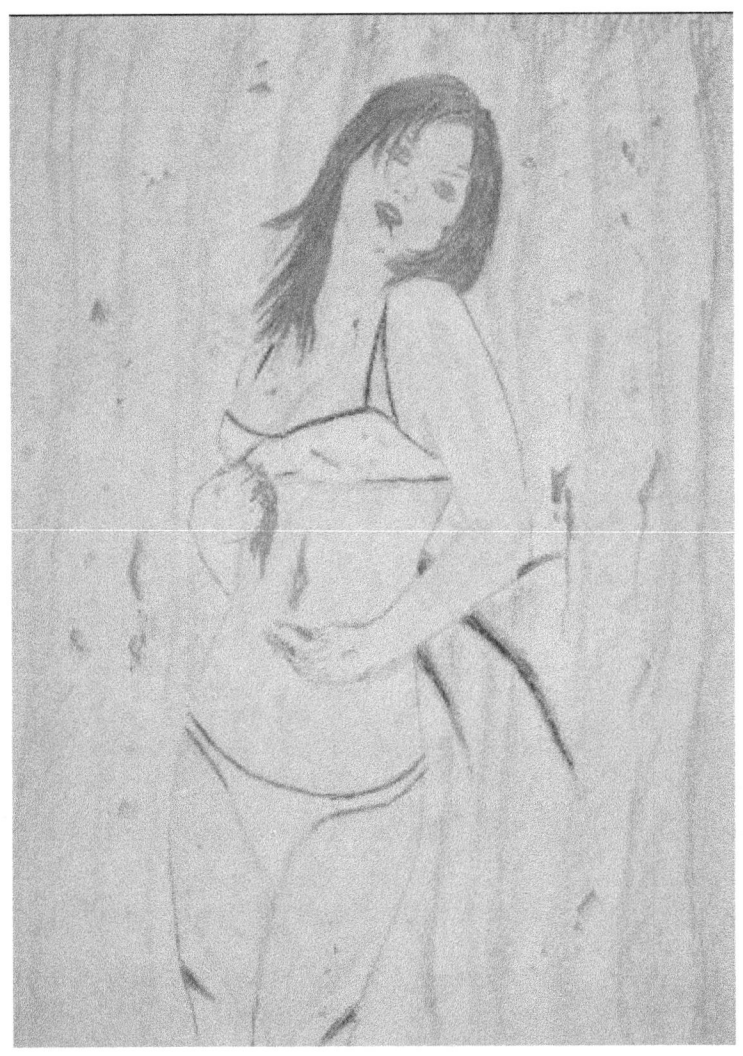

Cybergoth 1

Discovering the cybergoth aesthetic, I found it immediately fascinating. Hair that can be ribbons, coils, wires—anything semi-industrial? How weird and different can that be?

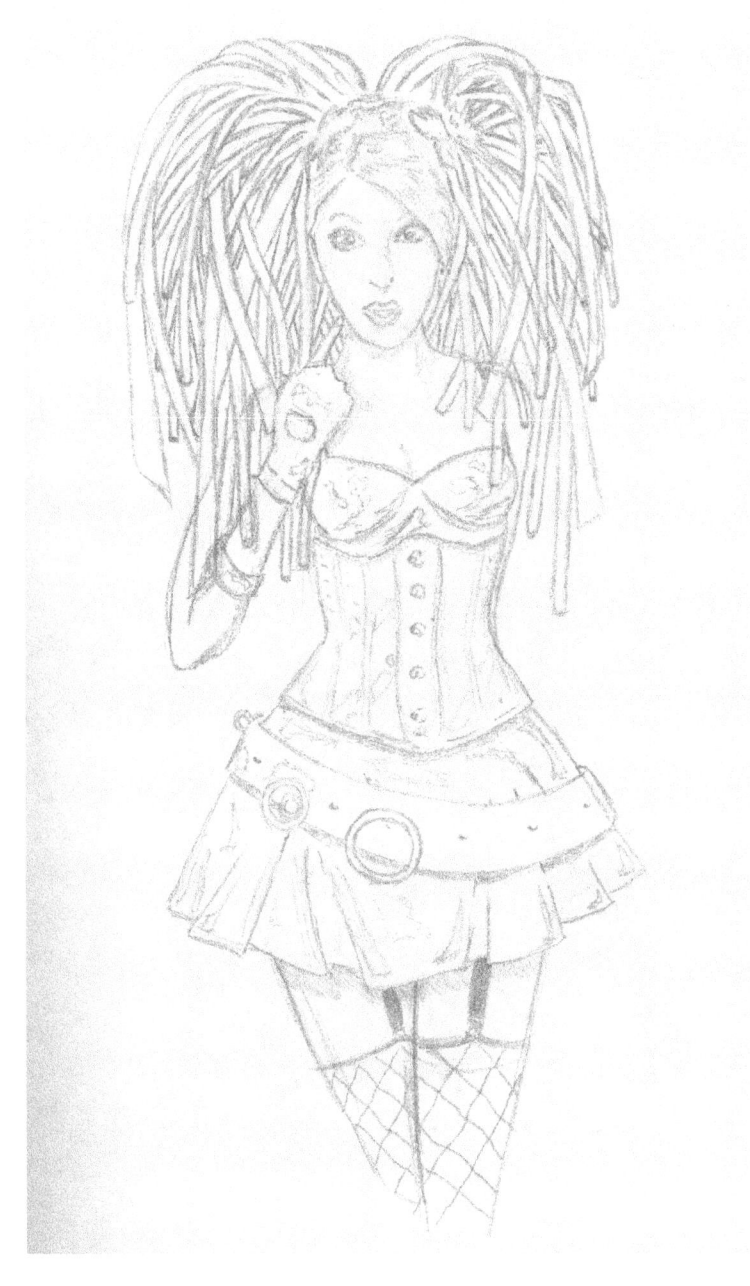

Cybergoth 2

Another cybergoth girl, another art style. This one has a more realistic shading to make her more than just a drawing.

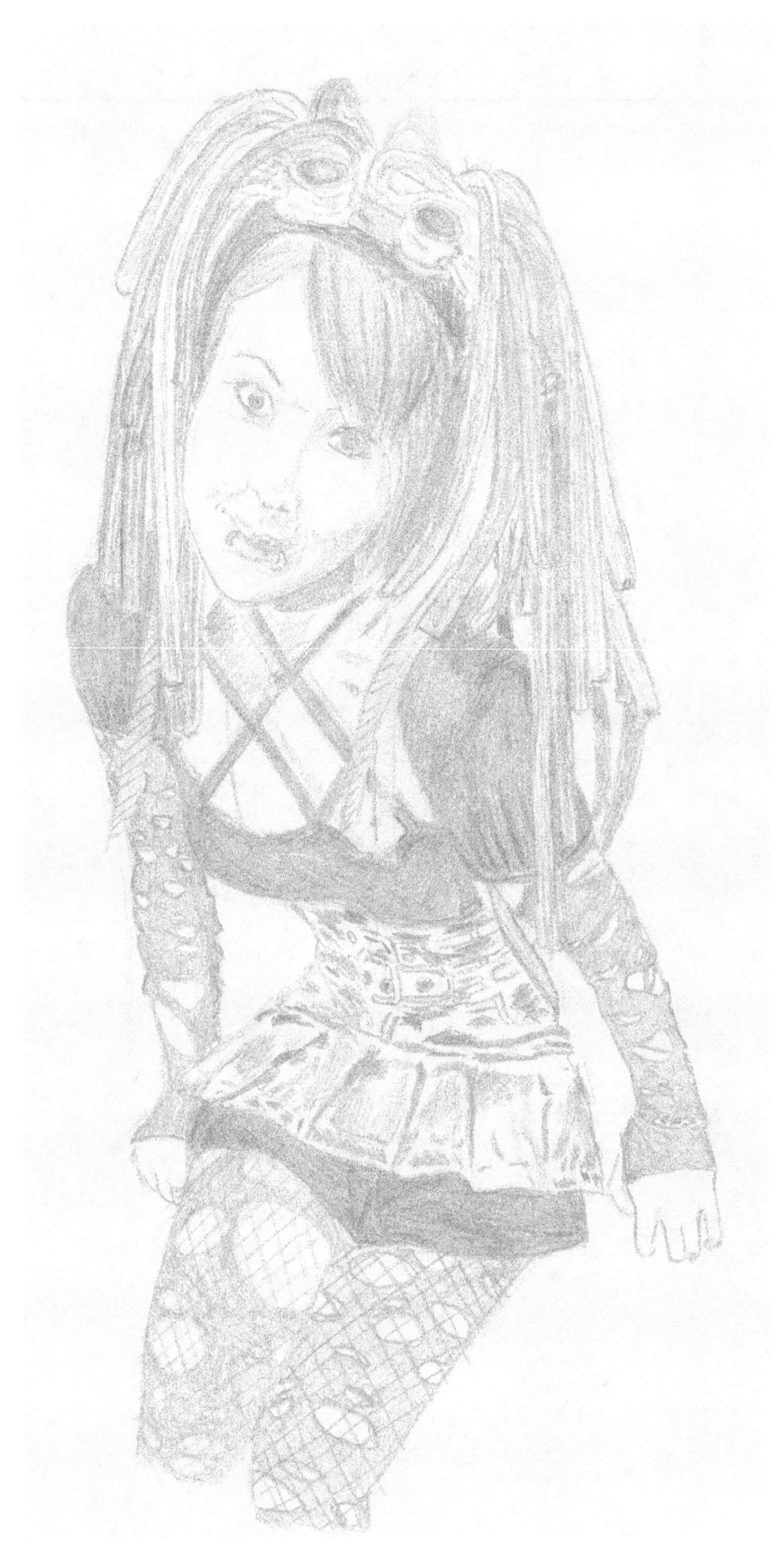

Cybergoth 3

This one is a wholly original design, no inspiration or reference required.

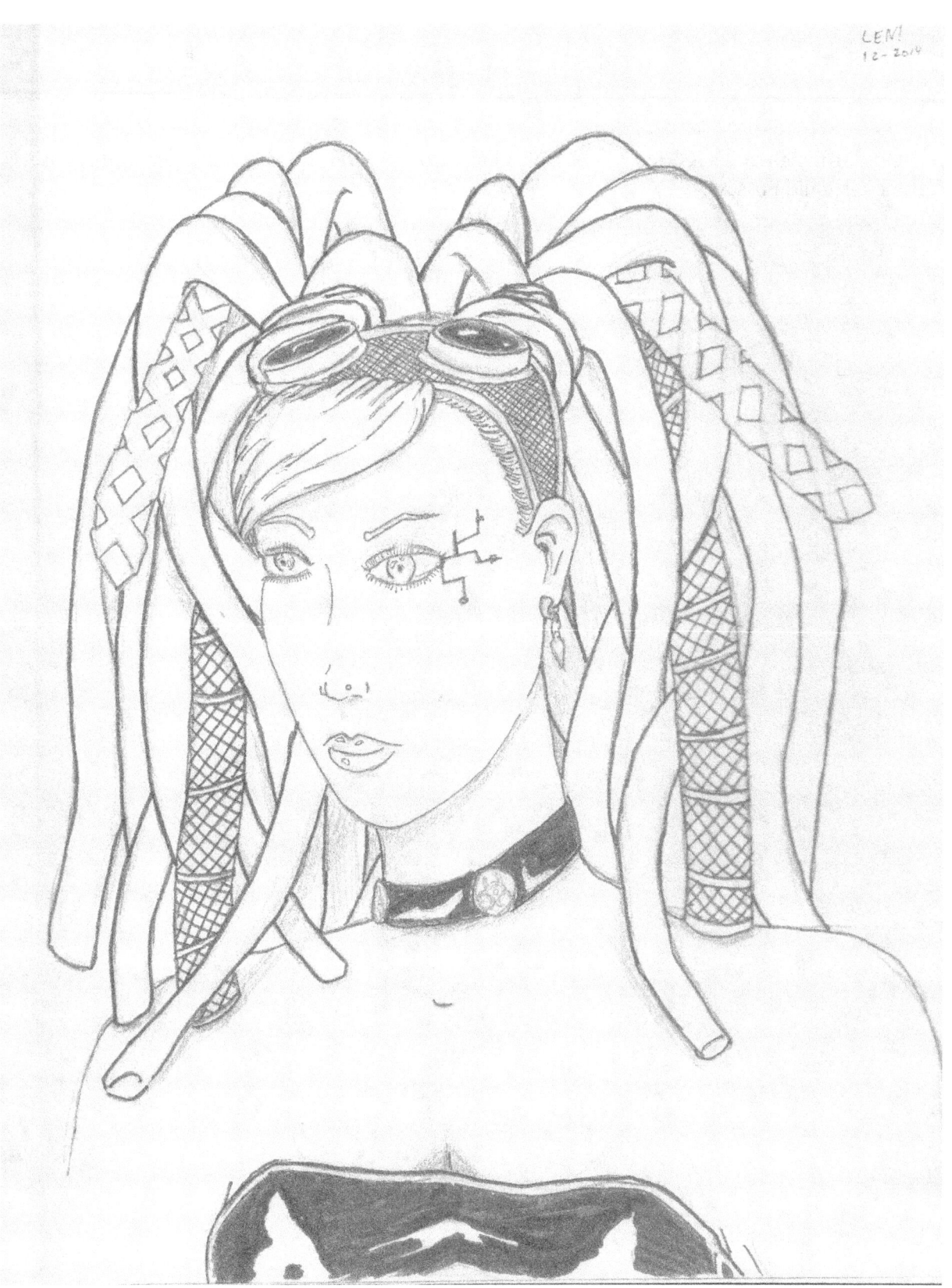

Phoenix

One of my favorite X-Men. Graceful, kind, strong. Everything a hero—or in this case, a heroine—should possess.

Papers and Implements

For the majority of these pictures, I used a *Master's Touch* bound sketchbook with 70 lb acid-free paper. Those images using black paper were drawn on *Master's Touch* 100 lb acid-free paper.

My preferred drawing tool is a *Kimberly* F pencil, a well-balanced tool for light or heavy drawing.

General's white charcoal is a fine pencil for working with black paper.

The ink pens I use switch between *Sakura* and *Faber-Castell*, depending on the tip size I want to use.

Any pre-drawing I do uses *Prismacolor* Non-Photo Blue pencils.

Some digital enhancements were done using *Adobe Photoshop CS2*.

[Intentionally Left Blank]

[Intentionally Left Blank]

[Intentionally Left Blank]

[Intentionally Left Blank]